Games
for
Teaching Art

Sandra L.H. Alger

J. WESTON WALCH PUBLISHER

PORTLAND, MAINE

User's Guide
to
Walch Reproducible Books

As part of our general effort to provide educational materials which are as practical and economical as possible, we have designated this publication a "reproducible book." The designation means that purchase of the book includes purchase of the right to limited reproduction of all pages on which this symbol appears:

Here is the basic Walch policy: We grant to individual purchasers of this book the right to make sufficient copies of reproducible pages for use by all students of a single teacher. This permission is limited to a single teacher, and does not apply to entire schools or school systems, so institutions purchasing the book should pass the permission on to a single teacher. Copying of the book or its parts for resale is prohibited.

Any questions regarding this policy or requests to purchase further reproduction rights should be addressed to:

Permissions Editor
J. Weston Walch, Publisher
321 Valley Street • P. O. Box 658
Portland, Maine 04104-0658

Cover photography: ©1995 John Alphonse

1 2 3 4 5 6 7 8 9 10
ISBN 0-8251-2652-5

Contents

Foreword

Teachers have been offering instruction in art production for decades, often with limited supplies and training. Specialized art teachers have been employed in many school systems to provide instruction in the visual arts. These teachers often receive the bulk of their training in visual arts production. Many art teachers are given an introduction to the concept of discipline-based art, which includes the four domains of art history, criticism, aesthetics, and production. They learn about the content of a discipline-based curriculum and may receive some training in its implementation. In many of these cases, the teacher is sent into the classroom, perhaps with a curriculum guide, but with limited resources for making the discipline-based curriculum an active reality.

The idea for this book came to me as a school art teacher. I found that I had a curriculum full of ideas and goals for the production of art. I was able to find resources with information about artists and visuals of their work. However, as I planned each unit, I lacked a resource that showed me how to take the information and activities and introduce them in interesting ways to my students. This book began as a few ideas for motivational art games, and grew as I found new ways to present information in each of the four domains. Many of the games are based on the structure of existing games or game shows, and contain content from the art curriculum.

This book is written for anyone who is in a position to teach art. It is intended to be a resource for teachers planning art experiences in art history, criticism, aesthetics, and production. Once the lesson content has been selected, these games can be used to make the lesson more fun.

About This Book

About a year ago, I read about the frustrations of an art teacher named Mrs. Rosenwald in an art education journal. They were feelings with which I could identify.

> *Here I am, an art cart teacher, and I'm not only teaching puppetry to all grades, but I've got all three sections of the fourth grade making Pariscraft puppets and scenery and staging performances for Parents Day. Why aren't I hearing: "Hats off to you, Mrs. Rosenwald. However do you manage it and all from an art cart?" But, no. What I do hear is that all this is not enough. There should also be art history. Now, can you see me finding the space to add a screen and slide carousels to this cart or finding the time to borrow and sort slides after refilling the glue?*
>
> *Besides, to show slides means five minutes to set up, ten to show. That's fifteen minutes from the forty I've got with the kids. This leaves twenty-five minutes to motivate, distribute, finish and clean up. Impossible. The only other option is to give over the whole period to art history, and the kids hate that. They want action, not facts, and we have little enough time for that. Forty minutes once a week. You know what that is for the year? That's twenty-four hours. So tell me about art history. . . and criticism. . . and aesthetics. Put all that into class time, and what happens to art—I mean the real art, the stuff I love to teach and the kids love to do?*
>
> (Katan, 1990, p. 61)

Even though I currently have an art room and an hour for each art lesson, as an art teacher I feel the pressures of limited time, the requirements of special school programs, and the increased demand for high quality lesson content in the areas of art history, criticism and aesthetics. Unfortunately, just providing quality studio experiences taxes the time and resources of my art program. It seems that the educational planners and theorists are constantly placing new demands on our teaching time. We are charged with adding more content within the same time frame, and doing so in a manner that engages the student. But how?

Mrs. Rosenwald was concerned about the interest level of the students. She should be—in order for students to learn, they must be intrinsically motivated or interested in the subject at hand (Eisner, 1988). Mrs. Rosenwald made the mistake of assuming that art history content could only be taught by viewing slides. She was doing her best to make her lessons engaging, even fun, for her students. She taught new types of puppetry to her students each year. Through

these sequential, annual units, she also managed to introduce her students to the history of puppets and to their uses in different cultural contexts. The contrast of a variety of styles also introduced the students to the aesthetic values of different cultures. Students began to learn art criticism skills as they compared these different styles. Mrs. Rosenwald's story motivated me to write this book—to present activities for teaching comprehensive art content while maintaining student interest.

This book includes activities in the four domains of art history, criticism, production, and aesthetics education. Activities are presented by domain. Within each domain, activities are based on clearly stated objectives and are organized by level of difficulty, with more sophisticated activities following easier, more basic ones. The games present students with specific art content and vocabulary such as art concepts, aesthetic viewpoints, and the steps of art criticism. However, they may be used with lessons on a variety of topics in art. The activities are often referred to as games, meaning that they are enjoyable (and therefore motivating) and structured, but not necessarily competitive. Many of the games promote problem solving, which is intrinsically motivating to students (Eisner, 1988). Art activities also need to be multisensory, particularly including the sense of touch (Katter, 1988). In keeping with this aim, many of the games involve children in active role-playing situations and include the use of props or special "disguises." The primary goal is to involve students in the active consideration and discussion of art works.

The content presented in each of the domains is described briefly on the first page of that section. In the areas of criticism, aesthetics, and production I have presented models designed by Dr. Jane Bates of Towson State University. Her models provide clear descriptions of the processes in each of these domains.

I designed the games for use within the classroom setting. The games involve the entire class in an active way or, in the case of role-playing activities, make the job of the audience interesting. They are designed to be used with a whole class or with groups working together within the class. The games are flexible, so that once the game has been made and introduced to the students, it can be adapted to a variety of lesson topics with minimal preparation by the teacher. Time allotments are not given for the games—the amount of time will vary depending on the subject matter addressed, the interest level of the students, and the amount of follow-up discussion pursued by the teacher. However, once the games have been introduced, many can be played in partial or shortened versions during those unexpected extra moments of class time.

The list that follows contains suggestions that will help you to use this book most effectively.

SUGGESTIONS FOR USING THIS BOOK

◆ Keep the book with your other planning materials. As you plan the content for an art unit, consult the book for ways of presenting the content.

◆ Start collecting art reproductions for use in the activities that call for a variety of works.

◆ Introduce one game at a time. Some of the information will be new to the students, so you may want to limit them to one or two games in a domain the first year.

◆ Establish small groups or teams for your art classes, such as the students who sit together at a table, so that new groups will not have to be formed each time a game is played.

◆ Have some random grouping strategies available, so that students will have the opportunity to work with a new group on occasion. Grouping strategies can be sets of identical pictures, pieces of art work or fabric cut into sections, or cards naming famous pairs, trios, or groups. The pieces are passed out to the class at random, and then students are given time to match up with the members of their new group.

◆ When presenting a new activity, describe it to the students as a game. Games certainly appear more inviting to the average student than "learning strategies."

◆ Use the suggested props whenever possible. Many of the games can be played without the props (such as the masks in "What's My Viewpoint?"); however, props are intended to enhance the play aspect of the game.

◆ Allow students the opportunity to call on each other during play. This enhances the students' sense of power and adds to the feeling of team play, rather than teacher-directed instruction.

◆ Experiment with using games from each of the domains: art history, criticism, aesthetics, and production.

◆ Reduce the play aspect of the activity by eliminating suggested props, such as masks, which may intimidate older students. Change the activity from a game to a focused discussion. For example, rather than using a time machine, simply present older students with an artifact or reproduction as a catalyst for a guided discussion or writing assignment. (*Note:* Be certain to clarify if the work is a reproduction.) Similarly, the steps of "The Critic's Court" game can be completed without the props and roles.

◆ Alternatively, exaggerate games involving role play as a form of theater performance. Require advanced students to complete independent research regarding a work and to present their information to the class in a production. This approach particularly applies to "If Pictures Could Talk," "The Time Machine," and "The Critic's Court." Your approach will be determined in part by the group of students.

◆ Present the activity as a research assignment, such as designing a segment of the "Art Room Time Line."

◆ Use the activity for a class drill, completed on entering class to review information about an artist, style, specific work, or period of art history. This can be done with games such as "Which One Doesn't Belong?", "Describe the Artist," and "What's Alike? What's Different?"

◆ "The Dilemma Box" is particularly appropriate for older grades. Students can be required to bring in articles from the newspaper and magazines, defining the two sides of the argument to the class and presenting arguments for either side. Particularly relevant topics may become the focus of organized class debates.

◆ "The Idea Box" and "Visual Brainstorming" are appropriate for any grade. You may require students to bring in their own objects to add to the box, or to make their own, larger versions of the brainstorming web.

◆ "Describe the Artist" can be constructed as a set of individual cards, each containing a general question. Some of the questions may be yes/no, others may require discussion. Students then choose a card and respond based on their knowledge of the artist.

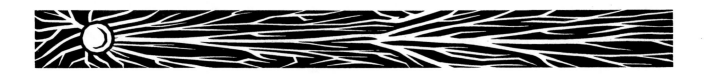

ART HISTORY GAMES

The study of art history, particularly with younger students, is more than a series of names, facts, and dates. It is also more than the cloning of artworks and styles developed by master artists. Instruction in art history develops an understanding of and appreciation for societies and people through the examination of their artworks. Art history includes the work of both Western and non-Western peoples and examines the connection of culture to nature and of individual to community and historical context (Katan, 1990).

With the vast array of artworks available for study, it is the task of the individual teacher or school system to choose specific works. Unfortunately, it would be virtually impossible to cover all art history topics within a child's public school career. The teacher must aim at providing a sampling of topics, so that students develop an appreciation for the diversity of art, as well as an understanding of specific styles. Students also need to develop an understanding of the place of specific artists and styles in time. Due to the fact that young students find it difficult to conceive of and understand periods of time, concepts about art through history must be introduced only as age appropriate (Smith, 1989).

The games in this section are based on the following goals:

◆ to allow students to examine an artwork in depth

◆ to develop an understanding of artwork as it relates to the culture of both the artist and the viewer

◆ to develop an understanding of the place of specific artists and styles in time

◆ to familiarize students with the specific stylistic qualities of an artist or movement

About the games . . .

◆ The first game, entitled "If Pictures Could Talk," is designed to provide students with an invitation to examine a specific work of art more closely. Students are asked to use their imaginations to speculate on the content of a work. Since no knowledge of art history is required, this is a basic game appropriate for any grade level.

◆ "The Time Machine" allows for a simple introduction to the concept of past and present time, without requiring a complex understanding of world history. "The Time Machine" can also be used to investigate other cultures.

◆ "Which Came First?" and "The Art Room Time Line" allow for a more complete historical perspective with older students.

◆ Finally, "Which One Doesn't Belong?" and "Describe the Artist" allow for the investigation of a particular artist or style.

◆ ◆ ◆ ◆ ◆

If Pictures Could Talk

OBJECTIVES

To identify the subject matter within an artwork.

To re-create the image through body placement, shape, sound, and vocalization.

WHAT YOU WILL NEED

1. An artwork (or reproduction) that the class will focus on.

2. A props chest or costume trunk with objects that will encourage students to re-create the image. Things you might want to include are: a variety of hats, an umbrella, artificial flowers, a cape, a jacket or blazer, glasses, plastic fruit, a tablecloth, bottles and vases, an old window frame, old wallpaper rolls (to make an instant background), etc. Your collection will build as you find objects appropriate for the prints you own. One or two props are generally enough to stimulate children's imaginative play. Props can be as basic as a classroom chair.

DIRECTIONS

Working in groups, students are given the task of re-creating the image of the artwork. Whether the work is representational or abstract, students can begin by using their bodies to be the objects or elements in the picture. Next, instruct students to imagine what the people or objects in the picture would say. Students are only limited by their imaginations. What are the people in *A Sunday Afternoon on the Island of La Grande Jatte* saying? What sound is the person in *Geschrei* (*The Scream*) making? How loud is it? For more abstract works, students may be given materials such as yarn, foil, or rolls of paper to wrap around themselves or other objects so that they become more like the images. Students should be encouraged to imagine a dialogue for abstract works as well.

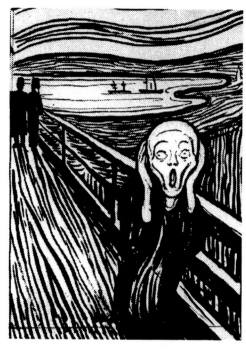

USES

This game is a good way to introduce students to a new work. Rather than simply being told what the work is about, students use their powers of observation and active imaginations to tell each other about the work. Students may work in small groups (the size of the group may depend on the complexity of the work) and then present their versions or skits of the painting to the entire class.

This game could be used in conjunction with "The Time Machine"; that is, a student may go into the time machine and return with information about the specific content of the work as the artist envisioned or created it. Journal entries, letters, or books about the artist could be left in the machine during class time. Students who finish other work early could travel back in time to do the research (reading) and return to present the information to the class. Another version would be to have students work together to create a news report based on the events within the painting or on the historical events at the time of its creation.

The game can be played with students of any age group who have active imaginations. It is particularly suited to younger children, who love to tell others what they see in an artwork or what they think a work is about.

Photo: National Gallery of Art. See "Photo Credits."

The Time Machine

OBJECTIVE

To develop an understanding of the history, culture, and time period surrounding an artwork or art form.

WHAT YOU WILL NEED

1. A time machine. This can be any elaborately decorated box. Adding knobs, dials, buttons, and working clocks to it will help give it an authentic appearance. Any size box will do. I built mine in a large box that a bookcase came in, so that it is large enough for the students to get inside. It is a good idea to have a prominent place where the date you will be visiting can be displayed. The book *Alistair's Time Machine*, by Marilyn Sadler, has a picture of an imaginary time machine and is also a good story for introducing the concept.

2. An object, clue, or image from the time period you are studying. The clue could be as simple as a reproduction of an artwork from the time, a letter written in that place or time, or some type of artifact such as a broken piece of pottery, an arrowhead, or an animal skin.

DIRECTIONS

I begin by explaining to my students that I have been experimenting and have built this time machine, which is run by imagination. I was thrilled when my students promised that they would have enough imagination to operate it! Since my time machine is quite large, one or two students are sent into the machine, the dials are set, and a moment passes. The students emerge with the clue they have discovered within to share with the class. Like a team of anthropologists, the class then examines the clue to discover what they can about life in the time

or culture. In small groups, students can discuss specific questions such as "What was life like in this culture?" or "What type of artwork did this society value?" Members of each group can then pose as anthropologists or museum guides to describe conclusions to the class.

USES

This game can be used to used to enhance any culturally or historically based unit. The key to success is finding good clues to hide in the machine. Specific examples include:

◆ pottery shards from an archeological dig conducted by the Smithsonian in 1919 at the Pueblo village site

◆ a model of a totem pole

◆ Northwest Coast Indian print

◆ objects from an artist's studio, such as cutout scraps or patterned fabrics from the studio of Henri Matisse

I have found that many students are willing to invent their own time machine experiences, based on things they know from history or from art class.

Which One Doesn't Belong?

OBJECTIVE

To identify and match the design qualities in the work of a particular artist or stylistic movement.

WHAT YOU WILL NEED

1. A set of five to ten postcards or other reproductions representing the work of an artist or style you wish to discuss. These may be selected from your collection of reproductions, if you are keeping one.

2. One or more postcards representing the work of a different artist or movement. The difficulty of the game will depend on the degree of similarity among all of the works chosen. For a younger age group or to introduce a new lesson, very dissimilar works may be chosen. For example, an action painting by Jackson Pollock could be included among several of Joan Miro's symbolic works. For older students or to review the qualities of an artistic style, more similar works may be selected. In the example below, students may be required to find the Monet among a group of works by Renoir.

Which one is not a Renoir?

Photos: National Gallery of Art. See "Photo Credits."

DIRECTIONS

The strategy for this game is simple. Present the class or small group with all the reproductions that you have selected. This can be done on the chalkboard with the students sitting nearby or with smaller groups of students sitting at tables. Ask the students to choose which picture or pictures do not belong. You may require students to work within a time limitation.

Another way to increase the difficulty of the game is to require students to determine how many artworks do not belong. Is there one misfit? two? or more?

USES

This game can be used at the introduction of a lesson or unit to assist students in identifying, through visual comparison, the stylistic qualities of an artist's work or of a movement. The game can also be used to summarize or review these qualities at the end of a unit. Also, by photocopying a set of reproductions onto paper, this activity could be incorporated into a unit quiz.

◆ ◆ ◆ ◆ ◆

Which Came First?

OBJECTIVE

To introduce the concept that art forms have been created throughout human history.

WHAT YOU WILL NEED

1. Images of six distinct types of artwork, from cave paintings to abstract art. My examples include (in chronological order) cave paintings, Egyptian masks and sculpture, Italian mosaics, a medieval tapestry, a landscape painting of the American West, and an abstract work. These are displayed in random order on the board.

2. A brief description of each work and its date written on a piece of paper. Fold these in half, pin them to the board, and write the type of work it is (such as *tapestry*) on the front. (The works could also be designated as A, B, C, etc., so that the cards could be reused.)

3. Numbers from 1 to 6, written on cards. These are pinned, with the blank side showing, in the correct order beside the pictures.

4. A set of cards for each group with the same identifications that are posted by the artworks (e.g., *tapestry*, or A, B, C, etc.).

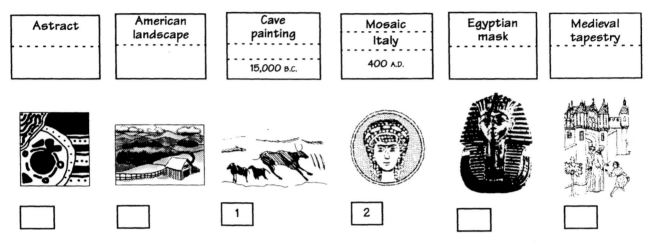

DIRECTIONS

The game begins with a brief description of each of the six types of artwork, focusing on the materials used to make each piece. Then, working in groups, the students arrange their cards from the oldest to the newest work. The sets of cards are then stacked in a pile and clipped to the board (magnetic clips can be very useful). The correct order is then revealed in game-show style. Two assistants check the sets to see which work the class thought was the oldest. Two additional assistants reveal the date of the painting and turn over the number. Then, the cards are checked to see which work the class believed was next, and the date is checked. Although everyone in a group may not agree, check the cards in the order most students feel is accurate. As you get close to the end, give the students an opportunity to change their answers. You can provide some hints if they appear stuck. (When I have played this game, students have had the most trouble with the American landscape painting and the abstract work. I have told the students that early scenes of the West were often painted as part of a series aimed at encouraging people to move west. This was often enough of a hint.)

USES

This game can be used to introduce the time line activity at the beginning of the school year.

Art Room Time Line

OBJECTIVES

To relate works in art history to periods in time that students understand.

To involve students in the creation of a time line to be used throughout the school year.

WHAT YOU WILL NEED

1. A background or setting on which to place the pieces of history (this can simply be colored paper arranged horizontally in an area of the classroom or hallway).

2. Dates to represent points in time, such as "Millions of years ago," 25,000 B.C., 5000 B.C., 500 B.C., A.D. 500, 1000, 1200, 1300, 1400, 1500, 1600, 1700, 1800, 1900, and 2000. These should be in place in the room when the activity is introduced. The amount of space between markers will depend on the space available, but more space will probably be needed for the 1800's and 1900's, the centuries most familiar to students and about which the most information is available.

3. Examples of art from each period of history. You will also need paper (I used 9 x 12) for the students to draw their contributions on.

DIRECTIONS

Create a time line for the classroom, using drawings by students of events, people, or inventions they know about from history. It helps to define history as anything that happened before today. Younger children will know a little world history but have a very poor concept of time. These children will relate better to illustrations of a more personal nature—a story from their own infancy or a story related by a parent or grandparent. Some of my younger students drew objects that belonged to a parent or grandparent. Older students will know about numerous historical figures, as well as events. They may also enjoy illustrating events from personal or local history. As the school year progresses, examples of artwork from various lessons and from master artists discussed can be added to the time line.

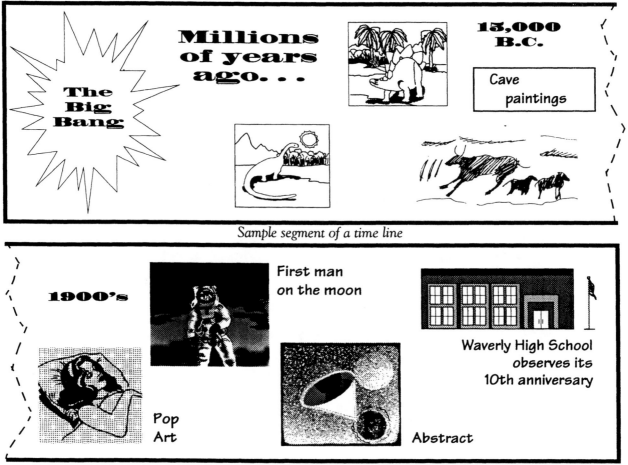

Sample segment of a time line

Sample segment of a time line

Children's stories can be a helpful way of introducing this activity. *Alistair's Time Machine*, by Marilyn Sadler, is the story of a boy who builds a time machine and travels back through time. He even has his portrait painted in a cave by some cavemen. *The Quilt Story*, by Tony Johnston and Tomie dePaola, tells of a quilt that was made for a small girl in pioneer times and is rediscovered by another girl in modern times. *The Keeping Quilt*, by Patricia Polacco, traces a quilt from its creation over several generations as a family heirloom.

USES

This is a useful activity for beginning the school year. It introduces students to the concept of art being created over time and throughout human history. The student illustrations make the time line more meaningful to the students than a commercial time line.

One other note: To encourage students to find the dates for their illustrations, I offered a prize for those turned in with dates. I also allowed students to go to the media center to find the date. This saved me some research.

◆ ◆ ◆ ◆ ◆

Describe the Artist

OBJECTIVE

To describe the specific qualities of an artist's work.

WHAT YOU WILL NEED

1. A game board, such as the one illustrated on the following page, with approximately twenty questions that define the work of an artist. Questions should require only a yes or no response. The questions are written on cards, which are attached to the board so that they can be lifted up. Before the game begins, the teacher must write the correct answer (yes or no) beneath each card. If the game board is made of a piece of laminated tag, answers can be written with projector marker and easily erased. The cards could also be individually magnetized and merely arranged on the chalkboard.

2. Samples of work by the artist to which students can refer to assist in determining the correct responses. For older students, you may provide written descriptions of artists and their works as well.

DIRECTIONS

Display the game board and artworks. The board should be arranged so that the question cards are visible and the correct answers are written beneath them. Ask students to use their knowledge of the artist and impressions of the works to consider the questions presented. Questions may be chosen and answered in any order. Likewise, students may not answer all questions in one session, but address the visible ones first and the others as their knowledge of the artist increases through class discussion and teacher presentations. Correct answers should be revealed as students offer them. This game could also be played on the chalkboard with students generating and answering their own questions.

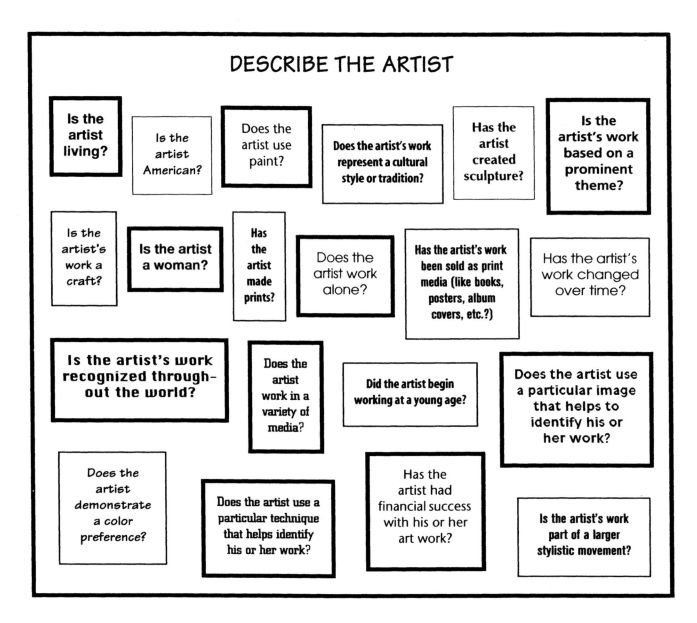

DESCRIBE THE ARTIST

Is the artist living?

Is the artist American?

Does the artist use paint?

Does the artist's work represent a cultural style or tradition?

Has the artist created sculpture?

Is the artist's work based on a prominent theme?

Is the artist's work a craft?

Is the artist a woman?

Has the artist made prints?

Does the artist work alone?

Has the artist's work been sold as print media (like books, posters, album covers, etc.?)

Has the artist's work changed over time?

Is the artist's work recognized through-out the world?

Does the artist work in a variety of media?

Did the artist begin working at a young age?

Does the artist use a particular image that helps to identify his or her work?

Does the artist demonstrate a color preference?

Does the artist use a particular technique that helps identify his or her work?

Has the artist had financial success with his or her art work?

Is the artist's work part of a larger stylistic movement?

USES

This game can be used to introduce the work of an artist or to summarize work during or at the conclusion of a unit. The questions may also stimulate further discussion, such as how the artist's work changed over time, or how the work reflects the artist's culture.

ART CRITICISM GAMES

There are a variety of approaches to art criticism in the art education literature that lead students through sequential steps in viewing and discussing art. The art criticism activities in this section are based on the criticism model designed by Bates (1994). Bates's model was chosen because it is clear, comprehensive, and connects the aesthetic viewpoints to art criticism while allowing for distinct content in aesthetics. Bates considers art criticism to be the process of seeing, discussing, and making judgments about the "visual environment." Bates's model includes the following six steps:

**ART CRITICISM
TEACHING MODEL**

1. **Motivation:** the artwork is presented and students discuss the art form, media, and techniques used.

2. **Identification:** students identify the subject matter of the work and name the objects they see.

3. **Description:** students describe the art elements of color, line, shape/form, and texture in the work.

4. **Analysis:** students analyze the relationships achieved through the use of design principles—balance, emphasis, subordination, contrast, transition, rhythm, repetition, pattern, and unity.

5. **Interpretation:** students attempt to discover meaning in the work, either for the viewer, the artist, or the culture of origin.

6. **Evaluation:** the quality of the work is judged by ranking it with other like artworks, based on a given set of criteria.

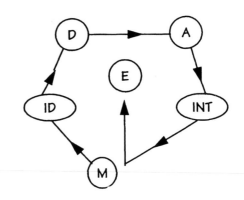

M = Motivation
ID = Identification
D = Description
A = Analysis
INT = Interpretation
E = Evaluation

All of these steps do not have to be completed for each critique, nor do the steps have to be considered in the order listed. However, Bates stresses the importance of having criteria by which to judge work during the evaluation. The criteria can come from the important considerations in the earlier steps.

The games in this section are based on the following goals:

◆ to introduce students to the steps in the art criticism model described above

◆ to provide students with specific practice in the art criticism steps, through the critique of their own artwork as well as the work of master artists

◆ to require students to define and identify the art elements and principles as used in works of art

◆ to identify, compare, and contrast design qualities in specific works of art

About the games . . .

◆ "The Art Exhibit" is a basic game that allows students the opportunity to present their completed artwork to the class and offer their own interpretation and evaluation of the work. This game is particularly useful for introducing younger or inexperienced students to the concept of a class critique.

◆ "What's Alike? What's Different?" uses a Venn diagram to compare and contrast two related works of art; focusing on the tasks of describing and analyzing.

◆ "The Clothesline Game" can be used to arrange works on a continuum based on any criteria, and could therefore be used for practice in description, analysis, interpretation, and possibly evaluation.

◆ "Will the *Real* ____ Please Stand Up" focuses on defining and identifying the art elements and principles used in a specific work.

◆ "The Critic's Court" is designed to introduce students to all of the steps involved in an art critique and to allow practice in each step.

◆ "Connecting Compositions" offers students the opportunity to review their knowledge of art elements and principles through the consideration of the design of works by master artists. This game also allows students to play independently.

The Art Exhibit
(or, Can I Show My Picture?)

OBJECTIVES

To allow students the opportunity to share their artwork in the format of a simple critique.

To review the criteria given for an art assignment.

WHAT YOU WILL NEED

1. An assignment with clear requirements for success, based on the use of subject matter, media, and the art elements and principles.

2. Students with a completed art assignment or a completed step in an assignment.

3. A place to display the student work. The display area does not need to be permanent. I simply use magnetic clips or masking tape on the chalkboard, but you could also make a display area with empty colored mats on a chalk or bulletin board. It is important to have enough space to display the work of the entire class, even if it is only temporary.

DIRECTIONS

I designed this activity in response to the constant requests of my art students to share their work with me and the rest of the class. Frequently, when their requests were granted they simply said, "Look!" I wanted the opportunity to find out more about their work while reviewing their understanding of the concepts behind the project.

The game works quite simply. Following completion of a project, students are asked to gather in the area of the room arranged for the art exhibit. There, we review the general criteria of the assignment. I then ask, "Who has work that is ready for our exhibit?" Individual students respond by showing their own work and explaining why it qualifies. The class then votes to determine if the work is ready. (Work is never actually rejected, but can be designated as "not ready at this time.") The accepted work is then added to the display area. The exhibit may continue to build until everyone in the class has contributed. The class may wish to create a name and description for their newly formed exhibit.

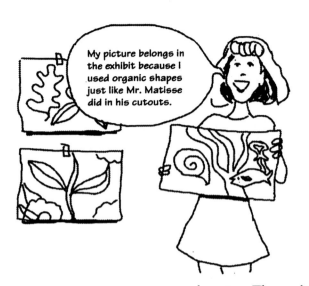

My picture belongs in the exhibit because I used organic shapes just like Mr. Matisse did in his cutouts.

It is a good idea to begin the class that day by reviewing the criteria and reminding students of the qualities that will make their work complete. This is added insurance that everyone will be ready for the exhibit.

Uses

This game can be used to share the completed artwork of any grade. With older students, you may wish to have them mount their own work for display and to place the exhibit in a more permanent location. The quality of the final presentation can become part of the criteria for acceptance into the show. With upper grades, the number of works to be accepted to the exhibit can be limited, if you wish to focus on works that most successfully meet the criteria.

◆ ◆ ◆ ◆ ◆

What's Alike? What's Different?

Objective

The objective of this game is threefold: to identify, compare, and contrast the specific design qualities of two works of art.

What You Will Need

1. A large Venn diagram (see the drawing on the next page). This can easily be made by overlapping two hula hoops leaned on the ledge of the chalkboard or laid on a floor or table, or by using masking tape on a flat surface. Of course, you could also draw one on large paper.

2. A collection of small reproductions of artworks. Postcard size is ideal. You can also cut reproductions out of museum pamphlets, magazines, or old books. Students can also draw or paint playing cards to add to the collection (index cards are a good size). The more reproductions in the collection, the more challenging the game.

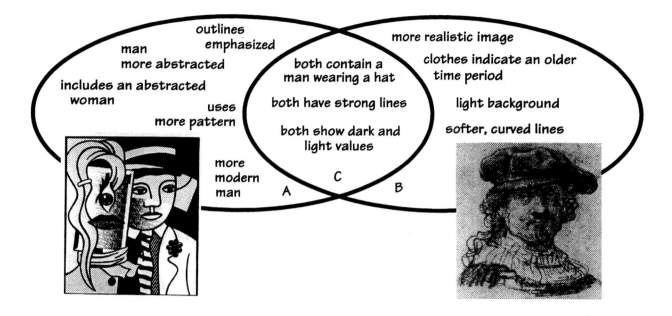

DIRECTIONS

Begin by placing the Venn diagram on a flat surface. Place one reproduction in each of the two outer areas of the circle. Players verbally describe design qualities that they see in the two works. Qualities unique to each work are written in the space containing the work. Qualities that the works share in common are written in the space created by the intersection of the two works. Observations may come from any of the parts of art criticism, including the subject matter or the media of the work, the use of design elements and principles, and the viewer's interpretation of the work. For example, in the diagram above, a work by Lichtenstein is placed in one of the outer areas (A). A work by Rembrandt is placed in the other (B). Qualities unique to Lichtenstein's work are described in area A, those unique to Rembrandt in B. Qualities shared by the two works are described in area C.

USES

This game can be used with the whole class to compare works you will be studying. It can also serve as a review activity at the end of a unit or as an extra activity for students who complete a project early. (It would help if they have played the game with the class before.)

All grade levels can play the game, with the use of age-appropriate vocabulary.

The Clothesline Game

OBJECTIVE

To compare and contrast opposite design qualities in works of art.

WHAT YOU WILL NEED

1. Two design qualities that you would like to contrast, such as objective versus nonobjective (abstract), as in the illustration on the next page.

2. A clothesline or rope and clothespins. You may also draw a clothesline on the chalkboard and use magnets to attach the reproductions.

3. A collection of small reproductions of artworks. Postcard size is ideal. You can cut reproductions out of museum pamphlets, magazines, or old books. Students can draw or paint cards to add to the collection (index cards are a good size). Choose several reproductions from the collection for the design qualities you will focus on today. One artwork for each small group is sufficient.

DIRECTIONS

The object of this game is twofold: to compare two opposing design qualities and to identify works that fit on a continuum between the two extremes.

Begin by attaching the clothesline to the chalkboard. (I use magnetic clips.) Write the two opposing design qualities at the two ends of the line. Choose an appropriate reproduction and place it at its end of the line. Choose a reproduction exhibiting the opposite quality and place it at the other end. Play continues with students placing the remaining reproductions on the continuum in their appropriate locations, until all the reproductions you have chosen have been placed. The class may wish to offer input into the arrangement and move some works.

Abstract *Objective*

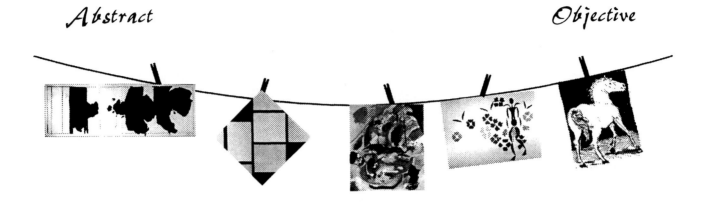

USES

This game can be used with the whole class to introduce design qualities in a work or works you will be studying. It can also serve as a review activity at the end of a unit or as a fun activity for students who complete a project early (it would help if they have played the game with the class before). When using this game to introduce a new work, the teacher chooses the first reproduction. For example, in introducing Japanese prints, the teacher may wish to focus on the use of diagonal lines. She begins by choosing a Japanese print and writing "diagonal lines" at one end and "horizontal lines" at the other. If reviewing a work or concept, students may be allowed to choose the initial work.

The game can be played with all grade levels, using age-appropriate concepts.

◆ ◆ ◆ ◆ ◆

Will the <u>Real</u> ＿＿ Please Stand Up

OBJECTIVE

To identify specific design elements or principles or to identify specific design qualities in the style of a specific artist.

1. A large sign that says "Will the *real* ＿＿ please stand up." The blank can be filled in each time the game is played. In my example, it would read "Will the *real* <u>pattern</u> please stand up."

Photos: Far right—Bequest of W.G. Russell Allen, courtesy
 Museum of Fine Arts, Boston. Others, National
 Gallery of Art. See "Photo Credits."

2. Three student volunteers.

3. Three artworks to compare or three images illustrating different design elements or principles. For example, to review the concept of pattern, I made images on three pieces of foam core. The first one was just colored orange, the second had a line pattern, and the third I left blank. The volunteers each held their image so that it was *not* visible to the rest of the class.

4. A card with a number on it for each player. These can be made like a necklace or sandwich sign to be worn around the neck.

DIRECTIONS

This game is based on the old television game show *To Tell the Truth*. The three volunteers can see the images and know which one fits the description. It is the job of the rest of the class to ask questions that will help find the correct image. The student volunteers each represent one of the three artworks or images. The rest of the students in the class ask the three volunteers questions about their works. Each question is addressed to one person, either number one, number two, or number three. The volunteers may only answer yes or no. Students must be encouraged to generate questions that will help identify the nature of the work. For example, if they know they are looking for one with a pattern, an excellent question would be, "Does it have stripes?"

Will the real __Symbol__ please stand up?

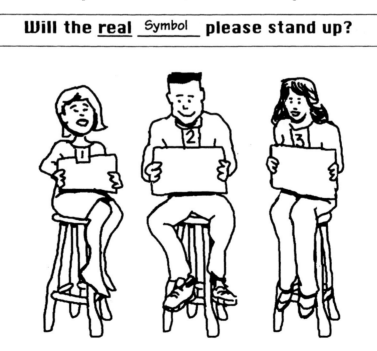

After a series of questions (I limit it to about twenty), the class votes on which volunteer has the right image. Is it number one, number two, or number three? The volunteers are allowed to make a statement about their work to try to convince the class that they have the correct image. Following the vote, the teacher says, "Will the *real* _____ please stand up." The three volunteers can each pretend they are the one and begin to stand up, but finally only the volunteer with the correct answer stands.

USES AND VARIATIONS

This game can be used to practice identifying a design element or principle or to identify the work of a specific artist. For example, if your class has been studying Picasso, a good review activity would be to play "Would the *Real* Picasso Please Stand Up?" One work would be a Picasso, the other two works would be by other artists.

The game can be played with the works seen by the class or hidden from view. As a general rule, if the object is to review an idea, artist, or style, the works should be hidden. However, if you are introducing a new idea, the works should be in view and the three students informed of the correct explanation of the new idea.

In the original game show *To Tell the Truth*, the visiting celebrities or volunteers were allowed, even encouraged, to give incorrect answers (in other words, to lie). However, for younger students, false answers could prove confusing. If you have older students or a class that is extremely confident in a subject, allowing freedom to try to trick the class can provide an element of excitement. This should always be attempted with the images in full view of the class.

◆ ◆ ◆ ◆ ◆

The Critic's Court

OBJECTIVE

To familiarize students with the processes of a formal critique.

WHAT YOU WILL NEED

1. An artwork to critique.

2. A large version of the "Critic's Court" visual, which describes the roles to the students.

3. The following props:

◆ A microphone for the game show host, whose role is to introduce the **motivation**

◆ A pair of old glasses for the witness, whose role is to **identify** the subject of the work

◆ A notepad and pencil for the reporter, whose role is to **describe** the art elements (line, shape, color, texture, space, and form) within the work

◆ A magnifying glass for the detective, whose job is to **analyze** the design principles of the work

◆ A dictionary or law book (or a book of art terms) for the lawyer, whose job is to **interpret** the meaning of the work

◆ A gavel for the judge, whose job is to **evaluate** the work

4. The following directions can be written on individual cards to be given to the various players during the game, or you may photocopy the descriptions on the following page.

Game Show Host:	Your role is to introduce the motivation. You will need to tell the class the title, artist, size, and medium of the work you are presenting.
Witness:	Your job is to identify what you see in the artwork. As a witness, you can only report what you definitely see!
Reporter:	You are only allowed to report the facts. Tell the class about the lines, shapes, colors, textures, form, or space that you see in the work.
Detective:	You must analyze the artwork. Look for ways the artist has created unity, emphasis, repetition, balance, variety, or rhythm.
Lawyer:	Tell the class what the artwork means to you. What do you think the artist intended?
Judge:	You must make the final evaluation of the artwork. Did the artist do a good job? You must tell the class how you made your decision.

THE CRITIC'S COURT

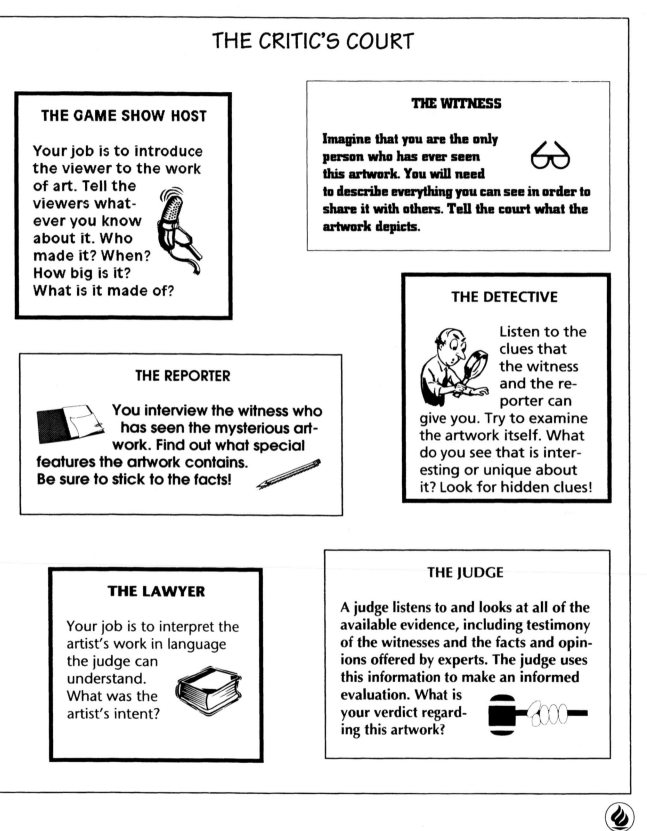

THE GAME SHOW HOST

Your job is to introduce the viewer to the work of art. Tell the viewers whatever you know about it. Who made it? When? How big is it? What is it made of?

THE WITNESS

Imagine that you are the only person who has ever seen this artwork. You will need to describe everything you can see in order to share it with others. Tell the court what the artwork depicts.

THE REPORTER

You interview the witness who has seen the mysterious artwork. Find out what special features the artwork contains. Be sure to stick to the facts!

THE DETECTIVE

Listen to the clues that the witness and the reporter can give you. Try to examine the artwork itself. What do you see that is interesting or unique about it? Look for hidden clues!

THE LAWYER

Your job is to interpret the artist's work in language the judge can understand. What was the artist's intent?

THE JUDGE

A judge listens to and looks at all of the available evidence, including testimony of the witnesses and the facts and opinions offered by experts. The judge uses this information to make an informed evaluation. What is your verdict regarding this artwork?

DIRECTIONS

This is a role-playing game patterned after Bates's art criticism teaching model. A different student may play each role. It is also possible for more than one student to play each role. (In fact, this may encourage a greater variety of observations and ideas.)

Encourage the students to use their props to help them to take on the role of the characters. Although all of the roles can be enacted in a given lesson, it is also possible to have only one of the characters visit your class on a given day, as it suits the needs of your critique or the time that you have.

It is also helpful for the teacher to introduce students to the game the first time by demonstrating the activity.

USES

This game can be used anytime that you want to have a critique. You may refer to the work of a master exemplar or to a student work. Similarly, the activity could be used at any point during the lesson. The witness may have a private viewing of a work and then be asked to describe it to the class to introduce a new work. During production, it may be helpful to have a visit by the reporter to report on the progress of the class or of an individual artist. At the end of class, the judge may be called on to assess the achievement of the class for the session.

This activity can be used with any grade, but it is best to introduce one role at a time. My students observed and described works by Marisol as if they were witnesses. Each group described a different work, and then, as a class, we viewed slides of all of the works and identified them based on the verbal descriptions.

◆ ◆ ◆ ◆ ◆

Connecting Compositions

OBJECTIVES

To review knowledge of the art elements and principles.

To identify the use of specific art elements and principles in the work of master artists.

WHAT YOU WILL NEED

1. A large collection of postcards or small images of artworks. These should be about the same size and represent a variety of artists, styles, movements, and time periods. The more diverse the better.

2. Students with a knowledge of the basic art elements and principles.

3. A set of criterion cards, each labeled with one of the following: line, shape, color, texture, space, form balance, emphasis, unity repetition, rhythm/ movement, technique, and media.

DIRECTIONS

This is a matching game. Set up by placing the reproductions in an area accessible to all students. A large class can be divided into smaller groups, each provided with an equal number of reproductions, or individual students may each be given a set of cards. Place the criterion cards face down in an equally accessible spot. Begin play by choosing a reproduction and placing it on the play area (tabletop or chalkboard). Then choose a criterion card and read it to the group. In the example on the following page, the initial reproduction is *Geschrei* (*The Scream*), and the criterion card chosen was the "line" card. Students look at the other reproductions to find a work that matches *The Scream*, based on the type of line used. The work could have curved, repeated, or black-and-white lines. If more than one player or group has a match, play proceeds around the room clockwise. The player places his or her reproduction next to the first while explaining the justification. For example, "This one connects because it also has repeated, curved lines." The class may move to reject a specific explanation by majority vote. If the match is accepted, the second player then chooses a criterion card and reads it aloud, and a new player is allowed to try a match. In the example, the next criterion card was "emphasis." Players chose a reproduction that they felt created emphasis in the same way as Rembrandt's *Self-portrait*. Players offer an explanation, such as, "This one connects because, in both, size is used to emphasize the figure." Play continues in this manner until one player or group has used all of their reproductions or until time is up. As more reproductions appear in the play area, players may connect or intersect their works with others, as long as the connection can be justified based on the criterion card chosen by the previous player.

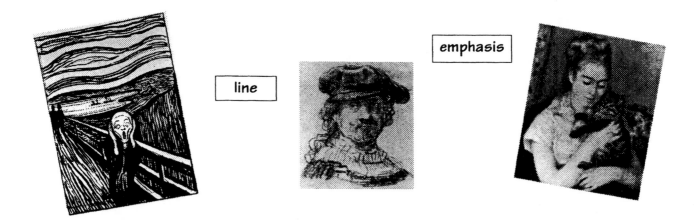

The illustration below demonstrates a more complete round of the game. In this example, the criterion cards were left between the matches for clarity.

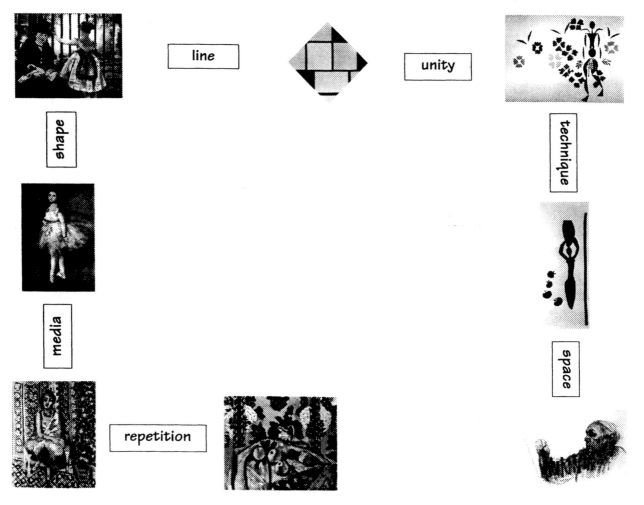

Photos: National Gallery of Art. See "Photo Credits."

USES

This game can be used to practice looking for the art elements and principles in the work of master artists. The game can be played noncompetitively by allowing all participants to choose from a common collection of reproductions, or competitively by giving the same number of works to each group or player and declaring the first to use all prints as the winner. The game can be played independently by a small group of students or with a larger group working at the board (adhere the pictures with tape or magnets). The game may be played by younger students using only the cards identifying art elements.

AESTHETICS GAMES

One important goal in a comprehensive art education is for children to consider the basis upon which they judge the quality of a work of art (Eisner, 1988). Theorists continue to debate the nature of an aesthetics education. For my students, I felt that there were two primary questions to address: What is art and why is art valued?

WHAT IS ART?

This question requires students to consider the nature of art as well as broader aesthetic issues and concepts, such as beauty. For example, students might consider whether an object must be beautiful to be considered art, or whether an image must be original. This type of discussion and inquiry can lead to the development of additional skills and attitudes, such as (but not limited to):

- thinking skills
- the valuing of questions
- the ability to tolerate uncertainty
- curiosity
- the ability to value thoughtful disagreement
- willingness to justify beliefs
- the ability to handle abstract ideas and to discuss them rationally
- the ability to participate in rational discussion
- the ability to distinguish opinion from argument, subjective from objective statements
- the ability to imagine possibilities (see Eisner, 1988, and Erickson, 1986)

WHY IS ART VALUED?

The question is addressed in two ways. The most basic approach is for students to share and discuss their initial reaction to a work. The second

approach is the consideration of a variety of aesthetic viewpoints. Although several theorists have described aesthetic viewpoints, the games in this section are based on the viewpoints described by Bates (1994). Bates labeled the viewpoints formalism, emotionalism (also sometimes referred to as expressionism), and imitationalism (also sometimes referred to as realism). These viewpoints relate to the steps in Bates's art criticism model. The relationship of the aesthetic viewpoints to the various processes in art criticism is diagrammed in Bates's model below. According to Bates, the goal of aesthetic education is to develop an understanding of and respect for a variety of viewpoints about art.

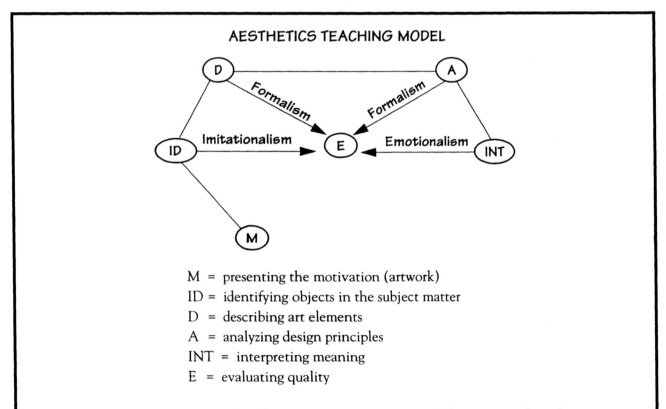

AESTHETICS TEACHING MODEL

M = presenting the motivation (artwork)
ID = identifying objects in the subject matter
D = describing art elements
A = analyzing design principles
INT = interpreting meaning
E = evaluating quality

♦ An **imitationalist** values the realistic representation of subject matter from the natural world. This type of work would be discussed in the identification step of art criticism.

♦ A **formalist** values the use of the art elements and design principles. Works valued for their formal qualities would be examined in the description and analysis steps of art criticism. A formalist may appreciate any type of work, including representational work, for its design qualities.

♦ An **emotionalist** values the feeling, or emotional impact, of an artwork, discussed in the interpretation step of criticism. Emotionalists may use realistic, abstract, or nonobjective means to create their works.

According to Bates, these theories reflect the views of Western culture. Non-Western works may or may not be created and viewed in terms of these theories. Since many non-Western cultures create artworks to serve functions in daily living, **functionalism** is an aesthetic theory suggested by Bates to present in the study of many non-Western art objects. Valuing a work because of the function it serves in a culture does not necessarily exclude also appreciating it for its imitational, formal, and/or emotional qualities. A single work may be appreciated from multiple viewpoints for different reasons.

The aesthetics games in this section are based on the following goals:

- ◆ to help students respond to art
- ◆ to consider the nature of art
- ◆ to teach students to think from all four aesthetic viewpoints.

About the games . . .

- ◆ Some of the activities, such as "Art Auction," begin with the students' initial response to a work—the aesthetic content most familiar to them.

- ◆ "Aesthetic Awards" allows students to identify specific qualities by which art is defined and valued.

- ◆ "One Point of View" introduces students to the individual viewpoints.

- ◆ "The Dilemma Box" presents discussion issues about the nature of art based on actual situations.

- ◆ "What's My Viewpoint?" and "Create a Gallery" offer practice in the understanding of the various viewpoints.

◆ ◆ ◆ ◆ ◆

Art Auction

OBJECTIVES

To encourage the emotional reactions of students to selected artworks.

To encourage the acceptance of a variety of aesthetic viewpoints.

To verbalize reactions to artworks.

What You Will Need

1. Several works of art that you would like to focus on (allow for one work per group, so that each group will have the opportunity to "purchase" one work of art). The works should be in a variety of styles and should include a variety in subject matter.

2. An auction paddle for each group

3. You may wish to provide some form of money or art credits.

Directions

This game is played in the format of an auction. Divide the students into groups, and choose a student to be the auctioneer (or play that role yourself). Begin with a period during which students may view the various works for sale and discuss their merits with the group. Tell students that their task is to choose the work they wish to purchase and to offer reasons for desiring a specific work. Next, provide each group with an auction paddle. The difference in this auction is that works are not purchased with money, but rather with reasons or justifications. When students raise the paddle to make a bid, they must offer one reason why they would like to own the work. The group that can offer the most reasons for wanting a work wins it. If a form of money or art credit is used, it can be handed out each time a reason is offered. (You may wish to designate someone as treasurer. This may help to keep track of the bids as bidding intensifies.) The class as a whole may determine if a justification is too vague or simplistic to be acceptable. It may also be helpful to write on the board some criteria for describing a work, including style, color, line, shape, texture, technique, detail, mood, story told, and subject matter.

As works are sold, groups who have not yet made a purchase may find it necessary to bid on their second, third, or fourth choice. This encourages students to consider possible reasons for enjoying a work other than their initial preferences.

Uses

This game can be used to introduce the concept of aesthetic valuing: that is, to teach students that artworks can be valued for a variety of reasons. It can also be used to introduce a new artwork, style, or culture to your class. It can also be used following a productive activity for auctioning student work.

The game can be played with most grades. However, when it is first introduced to younger students, you may need to offer suggestions for specific reasons a work may be valued. In addition, if students have previous experience with aesthetic or criticism games that require the verbalization of ideas about art, they will be better equipped for the auction.

◆ ◆ ◆ ◆ ◆

Aesthetic Awards

OBJECTIVES

To identify specific qualities by which artworks are defined and valued.

To promote class discussion of the aesthetic value of artworks.

To reinforce understanding of imitationalism, formalism, functionalism, and emotionalism.

WHAT YOU WILL NEED

1. A group of large art reproductions you would like your students to consider, or several examples of student work for consideration.

2. A set of the award cards, such as those on the following page, for each group participating in the game.

Name _____ Date _____

AESTHETIC AWARDS

Most beautiful

Most realistic

Took the most
time to make

Most original idea

Best composition

Most emotional

Most useful

**Note: You may wish to put
the written description on
the back of each card.**

34 *Games for Teaching Art*

DIRECTIONS

Begin by displaying the artwork to be considered. You may wish to have a variety of types of work. Give each group a set of cards. The first time you play the game, you will need to explain the meaning of each card. Allow the groups five to ten minutes to discuss the works and decide which card is appropriate for each. If opinions differ within the group, students can arrive at their final decision by majority vote. Following the discussion time, each group places their cards by the works they have chosen.

The game is concluded with a full-class discussion, during which each group is given the opportunity to explain why members placed the cards as they did. Some helpful discussion questions for the teacher to ask may include the following:

◆ Does anyone notice any trends or areas of agreement in the way the cards were placed?
◆ Which cards did the entire group agree on?
◆ Which cards required a group vote?
◆ Which cards did you have trouble placing?
◆ Were there any artworks that you did not put a card beside?

USES

This game can be used by any grade level to compare the qualities by which different artworks are valued. The game is appropriate for younger grades, as it limits use of terminology and focuses on opinions. The game may be made more difficult by allowing a group to place only one card at each painting.

This game can be used to compare different approaches to a medium or technique, to compare different artistic styles (either in master or student works), and to generate aesthetic discussion at any time during an art unit.

This game is an adaptation of the Token Response game developed by Eldon Katter.

One Point of View

OBJECTIVE

To introduce one of the four aesthetic viewpoints:

◆ **Formalism**, which appreciates a work for its design qualities

◆ **Emotionalism** (or **Expressivism**), which values a work for its feeling, or emotional impact

◆ **Imitationalism**, which values the realistic representation of subject matter from the natural world

◆ **Functionalism**, which values work that serves a specific function in daily life

WHAT YOU WILL NEED

1. An artwork that you would like to discuss, placed in full view of the class.

2. Individual cards that describe each of the four aesthetic viewpoints. These cards may be attached to a poster with Velcro™, so that they may be easily removed (see "What's My Viewpoint?").

3. Some type of token (such as a paper award, small buttons, etc.) to award for each appropriate answer.

DIRECTIONS

Play begins with someone choosing a viewpoint. The viewpoint may be chosen by the random selection of a card or designated by the teacher. The description of the viewpoint is read and explained to the class (particularly the first time the game is played with this viewpoint). Following time for thought and discussion, each group makes a statement about one of the works based on that viewpoint. For example, suppose one of the paintings is *Improvisation 31 (Sea Battle)* by Wassily Kandinsky, shown on the following page, and the viewpoint chosen was formalism. An appropriate statement might be, "The artist used repeated colors, such as red and blue, to unify the composition." For each valid statement about a work the group receives a token, and the group with the most tokens wins.

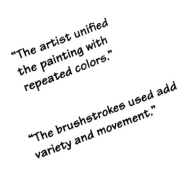

"The artist unified the painting with repeated colors."

"The brushstrokes used add variety and movement."

"The artist used several diagonal lines, which add to the effect of movement."

Formalism

USES

This game can be used to introduce a new artwork, style, or culture to your class. It is also a useful way of familiarizing students with the individual viewpoints prior to playing "What's My Viewpoint?"

A variation of this game would be to assign each group to a specific work out of a large selection and see which group can come up with the most statements about its work, from the designated viewpoint, within a given time frame. Another variation would be for individual students to write their own list of statements within a limited time. This could be a useful evaluative tool at the end of a unit.

◆ ◆ ◆ ◆ ◆

What's My Viewpoint?

OBJECTIVES

To identify the following aesthetic viewpoints:

◆ **Formalism,** which appreciates a work for its design qualities.

◆ **Emotionalism** (or **Expressivism**), which values a work for its feeling, or emotional impact

◆ **Imitationalism,** which values the realistic representation of subject matter from the natural world

◆ **Functionalism,** which values work that serves a specific function in daily life

(Refer to p. 30 for a complete description of each aesthetic viewpoint.)

Photo: National Gallery of Art. See "Photo Credits."

WHAT YOU WILL NEED

1. A work of art that you would like to focus on. Place the work or reproduction in full view of the class.

2. A poster or area on the chalkboard that explains each of the aesthetic viewpoints. (I made mine in the form of folded cards with the viewpoint named on the front and the description inside, so that I could conceal either piece of information if desired. These cards were attached to the board with Velcro so they could be removed.)

3. Four volunteers. Each volunteer will need a clear understanding of the viewpoint he or she is to represent. The first time that you try the game, you may want to introduce the various viewpoints at the beginning of class, leave your poster up throughout the class time, coach the four volunteers during the work session, and then play the game at the end of the class session.

4. Masks for each of the four volunteers, to conceal their identity and add to the excitement. Of course, the masks can be decorated. You may want to number or letter the masks so that these numbers can be referred to during the questioning part of the game.

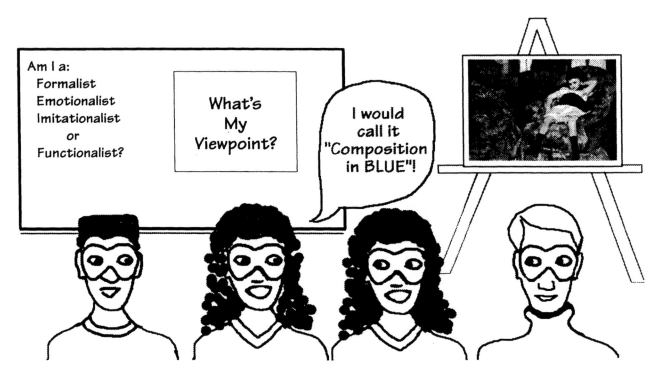

Photo: National Gallery of Art. See "Photo Credits."

DIRECTIONS

This game demands audience participation. Each of the four volunteers represents one of the viewpoints. It is the job of the audience to determine which player represents which viewpoint. This is done by the audience asking questions. For younger students, you may want to make a set of question cards which they can choose from at random. The role of the volunteers, or players, is to answer the question from their aesthetic viewpoint. Of course, questions should require the players to give specific responses.

The following is a list of sample questions:

◆ What would you title this work?
◆ How much would you pay for this work?
◆ Tell us something that you like about the work.
◆ Tell us something that you dislike about the work.
◆ If you could change one thing about the work, what would it be?
◆ Where do you think would be an appropriate place to hang this work?
◆ If you were giving this work as a gift, whom would you give it to? for what occasion?
◆ Would you like to hang this work in your house?

Members of the audience may direct their questions to a specific player, or to all four players. For example, "Player number one, what would you title this work?"

The questioning period can last as long as you have time and questions. Following the questioning, students in the audience can vote to decide which player represents which viewpoint. You may want to encourage some discussion about the choices before the final vote is taken. Following the vote, students can remove their masks and reveal their viewpoints.

USES

This game can be used to introduce a new artwork, style, or culture to your class. It can also be used at the end of a lesson or unit to review or summarize why an artist made a work and to allow the students to consider the work from a variety of viewpoints. The important thing about this game is that the artwork is considered from each of the four viewpoints, without valuing one viewpoint over another. Naturally, a work itself may be more valued by one viewpoint than another. For example, a realist would not value an abstract Frank Stella the way that a formalist or expressivist might.

The game can be played with most grades. However, when first introduced to younger students, the game may be limited to two or three viewpoints.

A variation of this game would be to guess the artist's viewpoint. In this case, one of the players could be the artist in disguise. Of course, for this version, both student and teacher must be well informed about the artist.

◆　◆　◆　◆　◆

The Dilemma Box

OBJECTIVE

To identify and discuss selected aesthetic issues.

WHAT YOU WILL NEED

1. A Dilemma Box. This is a box containing cards describing dilemmas in art. Dilemmas can be found frequently in newspaper discussions of local and national art exhibitions. (For example, should the National Endowment for the Arts provide financial support for the controversial Mapplethorpe exhibit?) Each card should present a single dilemma and include the following: a description of the situation, sample discussion questions, and two or more sides or points of view from which to choose. The card may also describe the people involved in the dilemma and which points of view they represent. The teacher can invent dilemmas or use actual events.

The first sample is an example of an actual dilemma, described in the book *Puzzles about Art: An Aesthetics Casebook*, 1989, by M. P. Battin, J. Fisher, R. Moore, and A. Silvers. This book is an excellent source of actual dilemmas. To complete the card, I have created questions and outlined sides the students can take. The second example is a fictional dilemma, but one which may occur in many art classrooms and that students can relate to directly.

Note: You only need one dilemma to play the game.

DIRECTIONS

Present the class or small group with the dilemma card. Allow students time to discuss the various points of view or arguments. (These may be elaborated on

(continued on page 43)

Sample Dilemma 1

Description of the Dilemma:

In 1983, an English woman, Ms. Gledhill, bought an abstract painting from a man who ran a pet shop. When she came into the shop, the owner was talking about the picture with an artist named Brian Burgess. Ms. Gledhill assumed that Mr. Burgess was the artist, and paid $105 for the painting. She thought she was getting a bargain. However, the painting was actually made by a duck named Pablo in the pet shop. Pablo had gotten out of his cage and walked through some paint. The pet shop owner liked the pattern made by the duck's feet, and let him walk on canvas in different colors. He said that the duck "has a real eye for composition and a flair for color." When Ms. Gledhill found out that the painting was made by a duck, she took it off the wall of her house, even though she said that she liked the way it looked.

Questions:

1. If Ms. Gledhill liked the painting, why do you think she took it off of her wall?
2. Who was the artist, the duck or the pet shop owner?
3. Does an artist have to be human?
4. Ms. Gledhill is not sure what to think of the painting that she bought. What would you say to convince her to hang it on her wall? What would you say to convince her to throw the painting away?

Choose a side and present your argument to the class:

If you were Ms. Gledhill, you would:

1. display the painting in your home
2. throw the painting away or store it in the attic

Sample Dilemma 2

Description of the Dilemma:

Last week, your art teacher explained that your class would be working on a special painting project. All week you worked on an idea for your painting. Today, when the class begins to paint, the student sitting next to you draws your idea almost exactly as it appears on your paper. As you continue to paint, the teacher comes over to look at your work. She compliments the student next to you for his excellent painting technique. You are angry because the idea was originally yours, yet the teacher seems to think the student beside you is doing a better job of painting it.

Questions:

1. How do artists get their ideas for artworks?
2. Must an idea be original to be art? Can you think of any famous artworks that were not based on original ideas?
3. Is a careful or precise technique required to create art?
4. Which is more important when creating a work of art, an original idea or careful execution?
5. What can you do when someone borrows your idea?

Choose a side and present your argument to the class:

This quality makes a better work of art:

1. an original idea
2. an idea that is executed very well

the card.) Assign students to present the arguments to the class. In some cases, students may wish to play the roles of the various interest groups and present their viewpoints in the form of a skit. In other instances, students may present a list of arguments and be allowed time for debate.

Uses:

This game can be used to promote small group discussion or a full-class debate. When working with the full class, small groups should be assigned to defend the various points of view.

◆ ◆ ◆ ◆ ◆

Create a Gallery

Objectives

To develop an understanding of the variety of aesthetic viewpoints.

To develop criteria for choosing works to include in a gallery setting.

What You Will Need

1. A collection of small visual images or reproductions of artworks. Postcards are the perfect size. Small reproductions can also be cut out of museum or gallery pamphlets, or magazines. Students will need at least twenty images to play the game. If you have a large collection of fifty to one hundred images, students can randomly select twenty images from the collection to use in the game. This will help keep the game interesting each time it is played. (You may also find that students will start to bring in images to add to the collection.)

2. A game board (see the sample). If the board is fairly large, it can be used by a small group or attached to the chalkboard for the whole class to see.

3. A set of cards naming and describing the four viewpoints:
 - **Formalism** appreciates a work for its design qualities
 - **Emotionalism** (or **Expressivism**) values a work for its feeling, or emotional impact
 - **Imitationalism** values the realistic representation of subject matter from the natural world.
 - **Functionalism** values work that serves a specific function in daily life

4. A pair of dice

DIRECTIONS

The object of this game is for the group to choose eight works to include in a gallery exhibit and to come up with a title for the art show that explains the relationship of the works. The game begins with each player choosing a viewpoint card. It is the player's job to choose works for the show that should be included, based on his or her aesthetic viewpoint, and to convince the other players that the works he or she prefers should be included. This is the tricky part. The secret is to justify the choice with reasons that would appeal to each of the viewpoints. For example, let's say that I have chosen a card with the **Expressivist** viewpoint, and I am trying to convince the group to include Munch's print *Geschrei* (*The Scream*). I could justify my choice by saying that I want to include the work because I can tell how the person feels from viewing the picture, but this would not convince players from other viewpoints. So I could add that the repeated lines give the work a strong sense of rhythm and the work depicts a recognizable figure in a natural location. These arguments might sway the **Formalist** and **Imitationalist** to include the work.

Play proceeds as follows:

1. Each player chooses a viewpoint card. The card is not revealed to the group.

2. The twenty works are randomly selected from the larger collection and displayed where all the players can see them.

3. Players roll the dice to determine who goes first. The highest number begins, and the others follow clockwise around the table.

4. The first player chooses a work he or she would like included in the gallery (based on the aesthetic viewpoint chosen) and offers reasons to justify the inclusion.

5. Players vote on whether to include the work. A work can only be included if three out of four players vote to include it. However, a work can be nominated by any number of players any number of times. When a work is voted in, it is placed in one of the spaces in the gallery. Play continues until eight works are chosen and the gallery is full.

6. To complete the game, students choose a name for their special show. At this time, they may reveal their viewpoints to each other. They may also want to present the exhibit to the class.

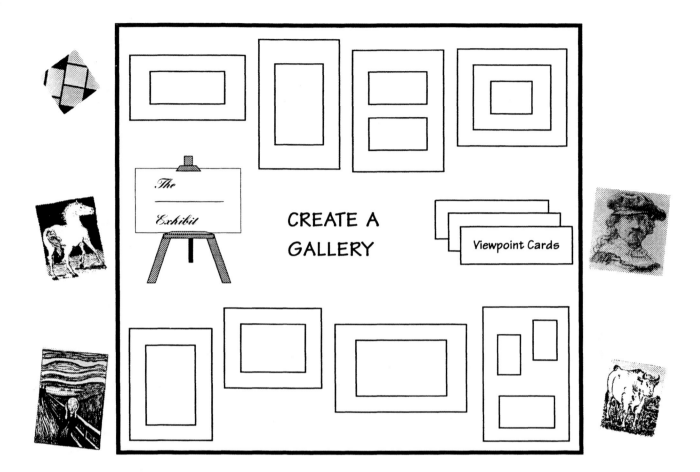

USES

This game is designed for a small group of two to eight players. With more than four players, students can work together in pairs. The game can be expanded to include more players if students work in teams. If the entire class plays, each group can work together to represent a viewpoint. This is a good way to teach the game to a whole class. After one round of play, students will be familiar with the game structure and more confident in playing in small groups. This is a good activity for students who finish their work early.

If you would like to make the game a little more challenging, make more than one card for each of the viewpoints. With this twist, two or more students or teams may unknowingly be defending the same viewpoint.

Due to the focus on independent thought and work, this game is best suited for older students. It is also very helpful if students have had prior exposure to activities involving the aesthetic viewpoints.

Photos: Left, middle and right, bottom—Bequest of W.G.
Russell Allen, courtesy, Museum of Fine Arts, Boston.
Others—National Gallery of Art. See "Photo Credits."

PRODUCTION GAMES

Art production is the component of a comprehensive art education that involves the making of art. Production involves three areas:

◆ Instruction in creative thinking skills. Thinking skills involve the ability to conceive of the visual image as well as to deal with changes in the image as work progresses. Skill is also required to make the materials achieve the image (Eisner, 1988). This is the essence of an artist's productive work.

◆ Instruction in a variety of media and processes of art. Art production includes instruction in the areas of drawing, painting, printmaking, crafts, and sculpture. Concepts based on the understanding of the elements and principles of design are introduced in each of these areas in an age-appropriate sequence.

◆ Use of instructional strategies appropriate to the goals of the lesson and the instructional levels of the students. There are three different types of productive activities: close-ended, open-ended, and laissez-faire, diagrammed in the chart below by Bates.

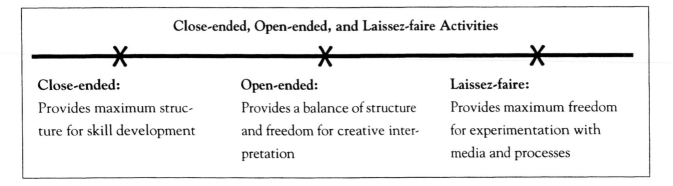

Close-ended, Open-ended, and Laissez-faire Activities

Close-ended:	**Open-ended:**	**Laissez-faire:**
Provides maximum structure for skill development	Provides a balance of structure and freedom for creative interpretation	Provides maximum freedom for experimentation with media and processes

Close-ended activities involve structured learning and are designed to teach specific skills or techniques. Students are given specific, step-by-step instructions for completing a given procedure in order to learn a skill. Close-ended activities are useful in teaching the appropriate use of a new tool, material, or technique.

Laissez-faire activities are just the opposite—they allow students complete freedom to explore media and express themselves. This type of activity teaches freedom of expression and exploration. Laissez-faire activities do not necessarily result in a final product, and if one is created, each product would certainly be unique.

Open-ended activities maintain a balance between these two extremes. A general structure is provided through broad criteria with the opportunity to interpret this structure in a variety of creative ways. This approach is used to promote thinking skills, to teach art concepts, and to promote the ability to make creative art objects. Students are required to find their own solutions to a problem within the guidelines established by the teacher.

All three types of activities are necessary within a comprehensive art education. Bates emphasized the need to choose the most appropriate type of art activity for the goals of an individual lesson. Open-ended activities are enhanced through the skills and insights gained from close-ended and laissez-faire activities. Close-ended are needed to develop the skills and laissez-faire activities are needed to encourage free exploration and self-expression. Bates asserted that high quality creative responses in open-ended activities require this prior building of skills as well as opportunities to explore media and processes.

The games in this section are based on the following goals:

◆ to develop creative thinking skills

◆ to instruct students in the use of a variety of media and processes

◆ to use instructional strategies appropriate to the goals of the lesson

About the games . . .

The production games presented in this section focus on the need for students to understand the process involved in the development of a visual image, to become familiar with the use of a specific technical process, and to develop creative thinking skills in relation to the design concept.

◆ "What's in My Pocket?" offers a simple review of art supplies or tools.

◆ "The Idea Box" allows students to generate ideas for the application of design elements and principles.

- "I'll Be the Teacher" allows students to demonstrate a technical process.

- "What Do I Do Next?" and "Build an Instant Process Visual" allow students to use thinking skills to determine or review the process for a specific project.

- "Visual Brainstorming" allows students to work in teams to generate multiple solutions to a problem.

The production games can be used with a variety of grade levels, media, and processes. They can be used with close-ended, open-ended, and laissez-faire activities, although "What Do I Do Next?" is generally a review for a close-ended process.

◆ ◆ ◆ ◆ ◆

What's in My Pocket?

OBJECTIVE

To identify a selected tool used in the production of art.

WHAT YOU WILL NEED

1. A tool that you will be using in today's art production activity.

2. A place to conceal the tool. This could be your pocket or a larger hiding place like a box.

DIRECTIONS

This game is played like twenty questions. Begin by asking students, "What do I have in my pocket?" Students are allowed to ask you yes-and-no questions to determine the nature of the tool. This game is a good way to encourage children to develop thoughtful questions. Sample questions include:

Have we used this tool before?

Have we used this tool this year?

Is it sharp?

Can you use it with paint?

Can you use it to cut things?

Is the tool all one color?

Is the tool made out of more than
 one kind of material?

Can you draw with it?

Do you use it to print?

Can you use it with clay?

Is it larger than my hand?

USES

This game can be used to introduce a lesson that uses a new tool, such as a printing brayer or a linoleum cutting tool. Students will, in effect, describe the tool for you before they even see it. This game can also be used at the end of a lesson to review new vocabulary when many new tools are introduced. Also, this is a quick game to play anytime you have a few extra moments of class time (for example, the teacher is late picking up the class or you actually cleaned up two minutes early).

This game can be played with any grade.

◆ ◆ ◆ ◆ ◆

The Idea Box

OBJECTIVES

To promote creative thinking skills.

To expand the use of the art elements and principles in design.

WHAT YOU WILL NEED

1. A box filled with a variety of materials. You will need a dozen or so pieces of each type of material. Materials can be grouped together in clear plastic bags or smaller boxes. (Bags are helpful because the contents can be seen without opening them.)

Here are a few suggestions for materials:

◆ pieces of yarn (in assorted lengths and colors)

◆ toothpicks

◆ straws

◆ lengths of flexible colored wire

◆ buttons

◆ fabric scraps, cut into a variety of shapes

◆ fabric scraps, cut or torn into long strips

◆ tagboard or mat board scraps, cut into a variety of shapes

◆ lengths of raffia or other natural fibers

◆ empty thread spools or film canisters

◆ a variety of small boxes

◆ cutout letters in a variety of sizes

◆ wood scraps (these can be purchased in packages of flat or round shapes) plain pieces can be obtained free from some lumberyards)

◆ polystyrene packing materials

◆ polystyrene meat trays cut into shapes

◆ assorted bottle and jar lids

You may include in the box any other materials that are plentiful, durable, and come in different sizes. Materials that bend are the most useful.

2. Two sets of cards. The first is labeled with the art elements: line, shape, color, texture, space, and form. The second, written on a different colored card, is labeled with design principles: balance, emphasis, unity, repetition, and rhythm/ movement. These cards can be stored in an envelope inside the top of the box.

DIRECTIONS

This box is designed to encourage students to explore the potential of a design element with the freedom of temporary materials. The procedure is simple. Players choose a card from the art elements pile—"line," for example. Then they

choose a principles card, for example, "rhythm/movement." Players may choose one or more of the materials inside the box to demonstrate the combination of art element and principle, in this case "line" and "rhythm/movement." In the drawing below, you can see one possible solution to this problem, using yarn and buttons. Naturally, there are an infinite number of solutions to any of the problems. The materials in the box allow players to experiment with possible solutions without having to make permanent marks on paper. Players may attempt solutions using several different materials.

USES

This game can be used with any grade that has a basic understanding of art elements and principles. A chart describing the elements and principles could be placed in the box top for reference. The game may also be played with the whole class, with the teacher choosing the element and principle. Each group of students could then use a different type of material to achieve the desired design effects.

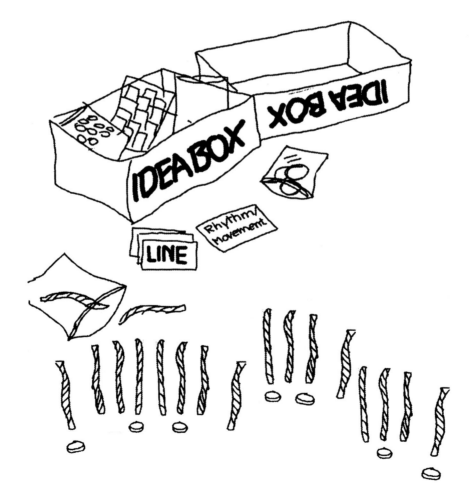

I'll Be the Teacher!

OBJECTIVE

To engage student participation and interest while demonstrating a technical process.

WHAT YOU WILL NEED

Two student volunteers, one to demonstrate and one to narrate, and the materials for a technical process that needs to be demonstrated. Naturally, this activity is most effective when the volunteers are familiar with at least part of the process.

DIRECTIONS

Do your students ever appear impatient during demonstrations? Have you ever heard "You're wasting our time!" or "When can we get started?" This activity encourages a great deal of student investment in the demonstration, helping students to see firsthand why they need to be reminded of a studio process.

Begin by choosing a student or students to demonstrate. To give them a sense of authority, allow them to borrow your smock or to use your special chair. Be sure to provide the demonstrator with all the materials needed for the process. Next, choose a narrator, who can be given a sense of authority with a pretend microphone. If the process is new to the class, you may need to be the narrator, guiding the demonstrator through each step. However, if you are reviewing a process, try to stay out of the demonstration and allow the students to take charge. As the demonstrator does each step, the narrator simply describes the action (sort of like a sportscaster at a golf tournament).

If the class seems fairly comfortable after a brief demonstration, you may ask the demonstrator to try to trick the class by omitting or incorrectly performing one of the steps. This involves the rest of the class in the task of discovering the mistake. It also helps to reinforce the importance of each of the steps.

USES

This game is most effective when used to review a process that has been previously introduced. I have also played it following a teacher demonstration of a new process. For example, one class was constructing papier-mâché totem poles.

Following my demonstration of the papier-mâché process (dip the strip, wipe it off, smooth it on, etc.), I asked, "Now, who would like to be the teacher?" The student demonstrator took my seat and continued to add strips to my example while the narrator described the action. I then asked the student to try to trick the class, skipping a step. (I often do this during teacher demonstrations.) The other students eagerly watched to identify the mistakes. They could also clearly see the results of a poorly executed process (like a very gooey totem pole). You may wish to use more than two volunteers.

This game can be played with any grade level. Naturally, the younger the students, the simpler and more familiar the process should be.

◆ ◆ ◆ ◆ ◆

Build an Instant Process Visual

OBJECTIVES

To provide a flexible, multipurpose process visual.

To engage students in decision making related to the steps in art production.

WHAT YOU WILL NEED

1. Pictures or drawings of the tools used in art class, including the following: erasers, glue, pencils, crayons, paintbrush, mixing palette, scissors, brayers, Exacto™ knives, rulers, and anything else you may be using. (You can add pieces to this game at any time.) These pictures can be used as both nouns and verbs in the process game. If you attach magnets to the back, the pictures can be easily manipulated on a magnetic chalkboard.

2. You will need to make some general cards, using words or pictures or a combination of both. These cards can also be magnetized. Some words and phrases you may need include: Imagine Examine Look Arrange Check your idea Be sure to include . . . Ask for help Spread out newspaper Make corrections Try a new idea Throw away small scraps Decorate Share your idea Supplies you will need Clean up.

3. A set of numbers for the various steps or a sequence chart with the numbers on it. You can also simply write the numbers on the board when you need them.

DIRECTIONS

This game works somewhat like a rebus. Using a combination of written words and pictures, students identify the steps in a creative process. The words and pictures are simply chosen by the students and placed in order on the board. If this activity is used to introduce an entirely new project or procedure, you will need to provide the class with an example of the finished product. You may also provide them with examples of what each step looks like, and then let them decide what you did to get there. This game also works well when partial sentences are written on the board, which the students can complete with pictures.

USES

This game can be used to introduce a new project or process, to review a process used previously, or to review a process introduced in the previous lesson. Of course, the more unfamiliar the project is to the students, the more information you will need to provide to assist them. The game can be played with the whole class working together to choose each step, with small groups (such as students sitting at a table together) working together to decide one of the steps in the process, or with small groups working on tabletop versions of the game.

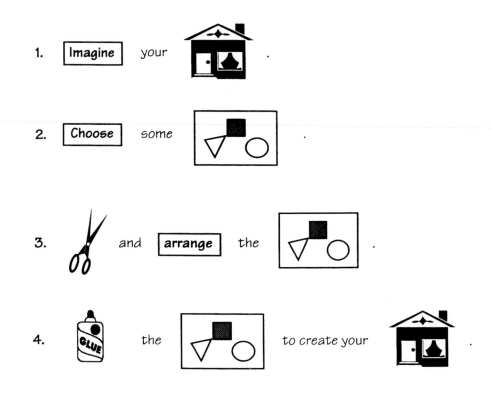

What Do I Do Next?

OBJECTIVE

To introduce or to review the steps in a technical process.

WHAT YOU WILL NEED

1. A copy of the sequence chain for each table or small group in your class. You can use photocopies and allow students to write on them or, if you want to save paper, laminate several copies of the sequence chain and let students use washable projector markers. The copies can then be washed and reused.

2. You may want to make a large, colorful, laminated version of the sequence chain to use on the board to display the correct answers following the game and throughout class.

2. A clock or timer.

DIRECTIONS

Do you ever get tired of hearing "What do I do next?" This game allows students to show you that they know the steps in a technical process and are ready to get to work. It also helps them to create a small tabletop visual that they can refer to as they work during class.

Begin by providing each table or group with a copy of the sequence chain and a writing implement. Establish the time limit (for example, four minutes) and let each group work together to complete their chain. When time is up, allow groups to present their answers and determine which groups are correct. A correct procedure should be filled in on the large visual (you can assign a student to do this job, à la Vanna White). You may award a prize to the teams who answered correctly. (The prize can be as simple as being allowed to get their supplies first.) Teams with incorrect chains should either correct their answers or refer to the chain on the board.

USES

This game can be used to introduce a new process. In this instance, you will need to provide the students with a lot of information. For example, you could

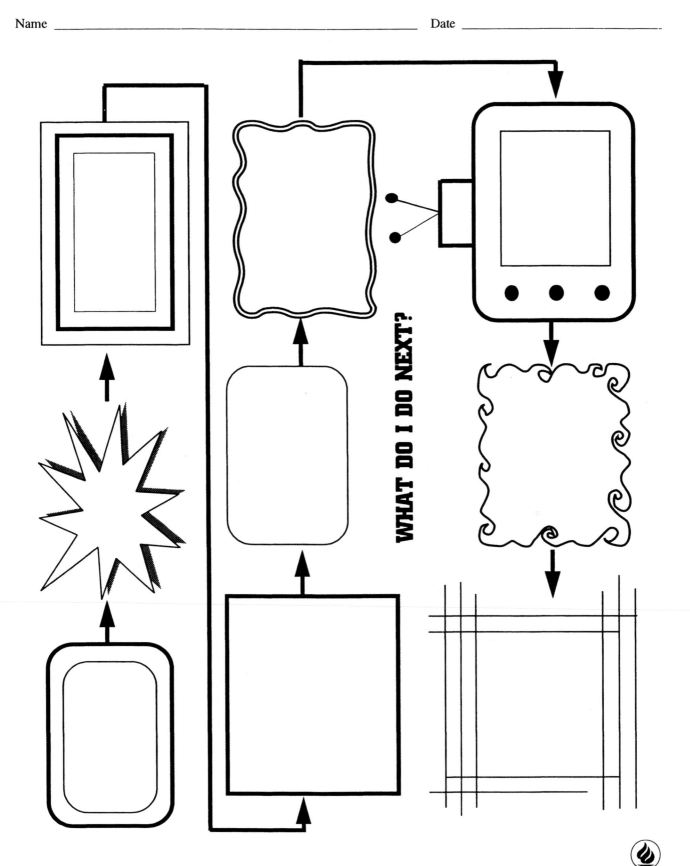

WHAT DO I DO NEXT?

provide the visual example of each step and let them explain the step in words, or you could describe the steps and let the students determine the correct order.

This game is also very useful as a review activity on the second day of a project involving a technical process. For example, on day two of a papier-mâché lesson, the game can take the place of a repeat demonstration or of your verbal review. The more involved students get in the discussion, the less likely they will need to ask, "What do I do next?"

◆ ◆ ◆ ◆ ◆

Visual Brainstorming

OBJECTIVE

To generate numerous solutions to a single design or technique question.

WHAT YOU WILL NEED

1. A copy of the web on page 60 or your own version. You can use photo copies and allow students to write on them or, if you want to save paper, laminate several copies of the web and let students use washable projector markers. The copies can then be washed and reused. You will need one copy of the web for each group.

2. You may want to make a large, colorful, laminated version of the web to display on the board or table and record some of the possible responses.

3. A problem you would like the students to consider. You may use any design or technique question with multiple possible answers. For example, "How many ways can you change a piece of paper to make it three-dimensional?" or "How many types of visual texture can you draw?" or "How many ways can you think of to change the shape of clay?" The question may relate to the work of a specific artist whom you are studying. For example, "How many different patterns can you find in Matisse's painting?"

DIRECTIONS

This game works best with students playing in groups. The group setting encourages teamwork and helps to generate a much greater variety of responses

than individual work. Each group simply needs a copy of the web and a pencil or appropriate material for recording responses. The material may be clay, markers, cut paper, etc. You may wish to give students a limited amount of time for generating responses. Following the allotted time, each group is given the opportunity to share their responses with the class. Some of the responses may be recorded on the large visual.

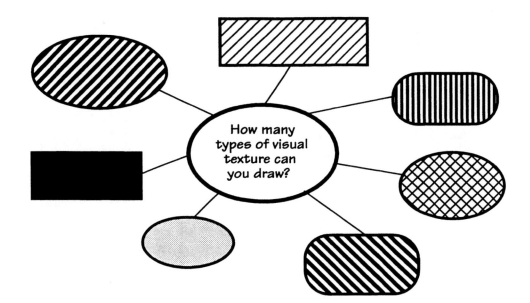

Uses

This game can be used anytime you want to expand student thinking on a particular problem. Some questions can be answered with words, while others will require small drawings. For example, it would be much clearer to draw visual textures than to describe them in words, since the intent is to expand visual thinking. You may even allow students to complete the web with the actual materials. For example, when considering ways of changing paper and making it three-dimensional, give students paper scraps to change and attach to the web. Perhaps you are thinking of a variety of ways to change the shape of clay. Students could write responses such as "roll" or "flatten," but a more effective approach is to use actual clay to try the possibilities and then to place the experiments on the web.

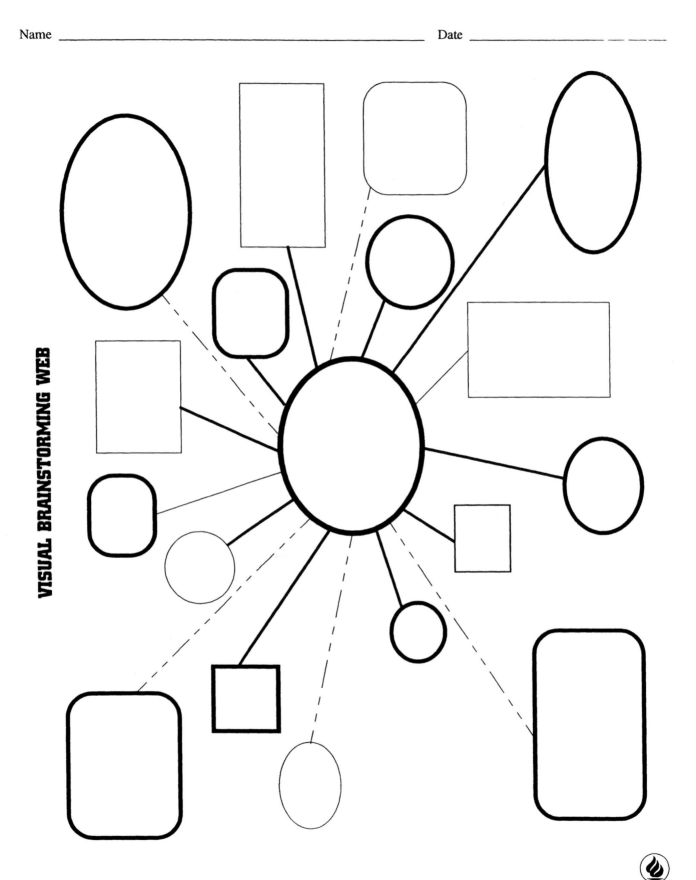

VISUAL BRAINSTORMING WEB

Games for Teaching Art

Definition of Terms

Aesthetic education—the consideration of the values or preferences applied to an artwork by the creator or evaluator

Analysis—a task in art criticism wherein students discuss the relationships in a composition achieved through the use of design principles—balance, emphasis, subordination, contrast, transition, rhythm, repetition, pattern, and unity

Art criticism—a series of processes in which students discuss visual qualities of works of art. These processes include motivation, identification, description, analysis, interpretation, and evaluation.

Art history—Art history refers to study of artists, cultures, and time periods, and their associated works of art.

Description—a task in art criticism wherein students describe the art elements of color, line, shape (which includes space and form), and texture in the work

Discipline-based art education (DBAE)—an approach to teaching art based on the inclusion of four content areas, or domains: criticism, art history and culture, production, and aesthetics. This may also be referred to as a comprehensive art education.

Emotionalism—an aesthetic viewpoint in which a work is valued for its feeling or emotional impact

Evaluation—a task in art criticism wherein the quality of the artwork is judged through comparison to other artworks on a set of criteria

Formalism—an aesthetic viewpoint in which a work is valued for its design qualities (use of art elements and design principles)

Functionalism—an aesthetic viewpoint in which a work is valued for the specific function or purpose it serves

Identification—a task in art criticism wherein students identify the subject matter of the work and name the objects they see in the subject matter

Imitationalism—an aesthetic viewpoint in which a work is valued for its realistic reflection of subject matter

Interpretation—a task in art criticism wherein students attempt to discover meaning in a work, either for the viewer, the artist, or the culture of origin

Motivation—a task in art criticism wherein the artwork is presented and students discuss the art form, media, and techniques used

Production—processes of creating art

Bibliography

Ahmad, P. "Fun and Games, But Learning Too." *School Arts*, 89(2) (1989a), pp. 24–26, 38–39.

———. "Fun and Games, But Learning Too: Part Two." *School Arts*, 89(3) (1989b), pp. 27–29.

Alexander, K., and Day, M., eds. *Discipline-Based Art Education: A Curriculum Sampler*. Los Angeles: The J. Paul Getty Trust, 1991.

Bates, J. "Learning to Teach Art." Unpublished manuscript, 1994.

Battin, M.P., Fisher, J., Moore, R., & Silvers, A. *Puzzles About Art*. New York: St. Martin's Press, 1989.

Eisner, E.W. *The Role of Discipline-Based Art Education in America's Schools*. Available from The Getty Center for Education in the Arts, 1875 Century Park East, Los Angeles, CA 90067, 1988.

Ende-Saxe, S. "The Elementary Critique." *School Arts*, 90(3) (1990), pp. 22–23.

Erickson, M. "Teaching Aesthetics K-12." 1986. Reprinted in S.M. Dobbs, ed. *Research Readings for Discipline-Based Art Education: A Journey Beyond Creating*. Reston, VA: National Art Education Association, 1988, pp. 148–161.

Feldman, E.B. *Becoming Human Through Art: Aesthetic Experience in the School*. Englewood Cliffs, NJ: Prentice-Hall, 1970.

———. "The Teacher As Model Critic." 1973. Reprinted in S.M. Dobbs, ed. *Research Readings for Discipline-Based Art Education: A Journey Beyond Creating*. Reston, VA: National Art Education Association, 1988, pp. 55–63.)

Hurwitz, A., and Madeja, S. *The Joyous Vision: A Sourcebook*. Englewood Cliffs, NJ: Prentice-Hall, 1977.

Katan, E. "Beyond <u>ART HISTORY</u>. . . and Before. . . and Beyond. . . and Before . . . and Beyond." *Art Education*, *43*(1) (1990), pp. 60–69.

Katter, E. "An Approach to Art Games: Playing and Planning." *Art Education*, *41*(3) (1988), pp. 46–48, 50–54.

Lankford, E.L. "Preparation and Risk in Teaching Aesthetics." *Art Education*, *43*(5) (1990), pp. 51–56.

Mitchell, V. "Parley with the Past: Creative Alternative to Lecture." *Innovation Abstracts*, *6*(4) (1984), pp. 3–4.

Szekely, G. "Preliminary Play in the Art Class." *Art Education*, *36*(6) (1983), pp. 18–24.

——— . "Teaching Students to Understand Their Artwork." *Art Education*, *38*(5) (1985), pp. 38–43.

———. "The Teaching of Art As a Performance." *Art Education*, *43*(3) (1990), pp. 6–17.

Taunton, M. "Questioning Strategies to Encourage Young Children to Talk About Art." *Art Education*, *36*(4) (1983), pp. 40–43.

Photo Credits

Page 3:
Edvard Munch, *Geschrei* (*The Scream*), Rosenwald Collection, © 1994 Board of
Trustees, National Gallery of Art, Washington

Page 6, *clockwise, from left*:
Auguste Renoir, *A Girl with a Watering Can*, Chester Dale Collection, © 1994
Board of Trustees, National Gallery of Art, Washington

Auguste Renoir, *Young Woman Braiding Her Hair*, Ailsa Mellon Bruce Collection,
© 1994 Board of Trustees, National Gallery of Art, Washington

Auguste Renoir, *Madame Henriot*, Gift of the Adele R. Levy Fund, Inc., © 1994
Board of Trustees, National Gallery of Art, Washington

Auguste Renoir, *Pont Neuf, Paris*, Ailsa Mellon Bruce Collection, © 1994 Board
of Trustees, National Gallery of Art, Washington

Claude Monet, *The Houses of Parliament, Sunset*, Chester Dale Collection,
© 1994 Board of Trustees, National Gallery of Art, Washington

Page 17, *from left*:
Roy Lichtenstein, *Stepping Out*, © Roy Lichtenstein. Courtesy Metropolitan
Museum of Art, New York

Rembrandt van Rijn, *Self-portrait*, Rosenwald Collection, © 1994 Board of
Trustees, National Gallery of Art, Washington

Page 19, *from left*:
Robert Motherwell, *Reconciliation Elegy*, Gift of the Collectors Committee,
© 1994 Board of Trustees, National Gallery of Art, Washington

Piet Mondrian, *Diamond Painting in Red, Yellow, and Blue*, gift of Herbert and
Nannette Rothschild, © 1994 Board of Trustees, National Gallery of Art,
Washington

Wassily Kandinsky, *Improvisation 31 (Sea Battle)*, Ailsa Mellon Bruce Fund, © 1994 Board of Trustees, National Gallery of Art, Washington

Henri Matisse, *La Négresse*, Ailsa Mellon Bruce Collection, ©1994 Board of Trustees, National Gallery of Art, Washington

Pablo Picasso, *Horse*. Bequest of W.G. Russell Allen. Courtesy Museum of Fine Arts, Boston.

Page 26, *top, from left*:
Edvard Munch, *Geschrei* (*The Scream*), Rosenwald Collection, © 1994 Board of Trustees, National Gallery of Art, Washington

Rembrandt van Rijn, *Self-portrait*, Rosenwald Collection, © 1994 Board of Trustees, National Gallery of Art, Washington

Auguste Renoir, *Woman with a Cat*, Gift of Mr. and Mrs. Benjamin E. Levy, © 1994 Board of Trustees, National Gallery of Art, Washington

Page 26, *bottom, clockwise from top left*:
Edouard Manet, *Gare Saint-Lazare*, Gift of Horace Havemeyer in memory of his mother, Louisine W. Havemeyer. ©1994 Board of Trustees, National Gallery of Art, Washington

Piet Mondrian, *Diamond Painting in Red, Yellow, and Blue*, gift of Herbert and Nannette Rothschild, ©1994 Board of Trustees, National Gallery of Art, Washington

Henri Matisse, *La Négresse*, Ailsa Mellon Bruce Collection, ©1994 Board of Trustees, National Gallery of Art, Washington

Henri Matisse, *Woman with Amphora and Pomegranates*, Ailsa Mellon Bruce Fund, ©1994 Board of Trustees, National Gallery of Art, Washington

Käthe Kollwitz, *Self-portrait, Drawing*, Rosenwald Collection, © 1994 Board of Trustees, National Gallery of Art, Washington

Henri Matisse, *Still Life with Apples on a Pink Tablecloth*, Chester Dale Collection, ©1994 Board of Trustees, National Gallery of Art, Washington

Henri Matisse, *Woman with Exotic Plant*, Chester Dale Collection, © 1994 Board of Trustees, National Gallery of Art, Washington

Auguste Renoir, *The Dancer*, Widener Collection, ©1994 Board of Trustees, National Gallery of Art, Washington

Page 37:

Wassily Kandinsky, *Improvisation 31 (Sea Battle)*, Ailsa Mellon Bruce Fund, © 1994 Board of Trustees, National Gallery of Art, Washington

Page 38:

Mary Cassatt, *Little Girl in a Blue Armchair*. Collection of Mr. and Mrs. Paul Mellon. ©1994 Board of Trustees, National Gallery of Art, Washington

Page 45, *left, from top:*

Piet Mondrian, *Diamond Painting in Red, Yellow, and Blue*, gift of Herbert and Nannette Rothschild, ©1994 Board of Trustees, National Gallery of Art, Washington

Pablo Picasso, *Horse*. Bequest of W.G. Russell Allen. Courtesy Museum of Fine Arts, Boston.

Edvard Munch, *Geschrei (The Scream)*, Rosenwald Collection, © 1994 Board of Trustees, National Gallery of Art, Washington

Page 45, *right, from top:*

Rembrandt van Rijn, *Self-portrait*, Rosenwald Collection, ©1994 Board of Trustees, National Gallery of Art, Washington

Pablo Picasso, *Bull*. Bequest of W.G. Russell Allen. Courtesy Museum of Fine Arts, Boston.

Notes